Vignettes Vignettes Vignettes
Vignettes Vignettes
Vignettes Vignette
Vignettes Vignettes V
Vignettes Vignette
Vignettes Vignettes V
Vignettes Vignette
Vignettes Vignettes V
Vignettes Vignette
Vignettes Vignettes V
Vignettes Vignette

MAXFIELD PARRISH
THE ART PRINTS

Michael J. Goldberg

Collectors Press, Inc.
Portland, Oregon

Acknowledgements

Collection courtesy of Erwin Flacks, Fine Art
Marketing Co., and the archives of Collectors Press, Inc.

Editor:
Michael J. Goldberg

Design:
Hoover H.Y. Li

Published by: Collectors Press, Inc.
P.O. Box 230986, Portland, OR 97281
1-800-423-1848

Printed in Singapore

First American Edition

10 9 8 7 6 5 4 3 2 1

ISBN: 1-888054-19-0

Maxfield Parrish

Utilizing their creative powers, many artists, writers, composers, et al., have bewitched us into distant times and lands – places found only in our deepest wishes and most wonderful dreams. As we close the door on the twentieth century we look back to see a man who opened the door at the beginning – who flooded our world with some of the most well-loved and nostalgic artwork in these last one hundred years.

Maxfield Parrish created his beautiful images of ethereal maidens and Mother Goose characters in a time when people were still capable of romanticizing the past in response to an ever encroaching

Land of Make-Believe
1912

twentieth century. Unlike Norman Rockwell, whose subjects were a product of the artist's nostalgia for a contemporary world as he wished it, Parrish evoked a nostalgia for a legendary world that was a mix of mythological, European, Oriental and Early American fantasies and subjects. In today's world, Maxfield Parrish's images are *still* as popular as when they were created. This cannot be said of many artists, even of fifty years vin-

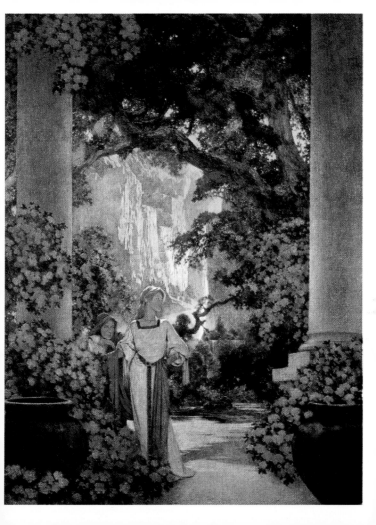

Cadmus Sowing the Dragon's Teeth
1909

tage. Not only is Parrish's work still prized, but many people, young and old, are actually familiar with different Parrish classics. His work has been raised to an almost iconographic level. As contemporary publishers reproduce Parrish images in the forms of books, calendars, trading cards, greeting cards, etc., they are eagerly bought by a public that seems to be insatiable for the Parrish persona. His name is more

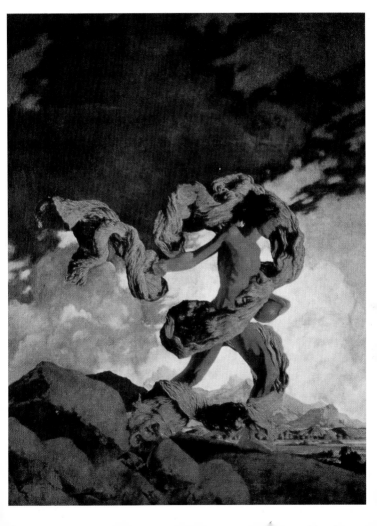

familiar to the public than most contemporary artists who struggle in a world where art is reduced to a commodity.

Parrish is more than profit though, he is also inspiration. In the late 1960s, young artists and designers felt that illustration (or any piece of fine art used in a commercial way) should still be considered art, a concept not particularly shared by the

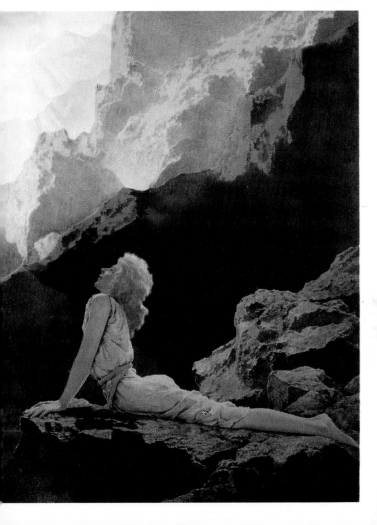

industry and quickly passed on to the eager public. In a counter-cultural move fueled by a new sense of nostalgia, these artists reached into the past to rediscover such artists as Parrish, as well as Aubrey Beardsley, Alphonse Mucha, M.C. Escher and others from the Art Nouveau Movement and the early twentieth century. These prototypal illustrators had attained a sort of "camp" romantic

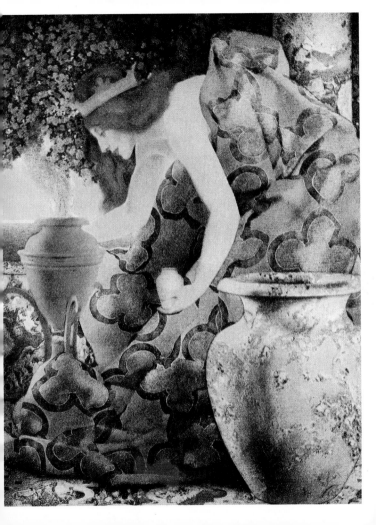

status for these young artists and they were quickly inspired to borrow freely from the styles. Parrish offered them great composition, beautiful figures and, above all else, an exquisite color palette and color technique.

When Coy Ludwig's definitive 1973 book *Maxfield Parrish* was published, contemporary artists such as Palatino, Byrd, and David Goines were producing posters with decidedly

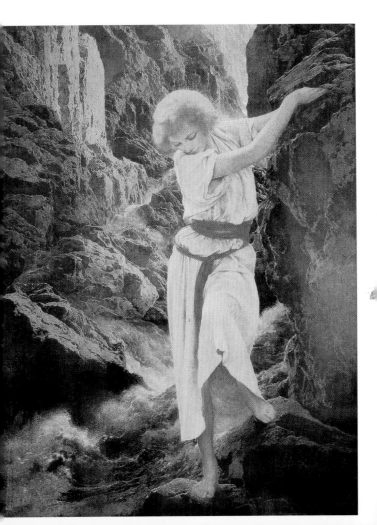

Parrish influences that were being
framed and hung as art. Posters had
finally achieved the status of art and
publishers were quick to see this fact.
Reproductions of some of Parrish's
well-known pieces appeared in print
and poster forms and Ludwig's book
had become the standard work on
Parrish and has since enjoyed many
reprintings.

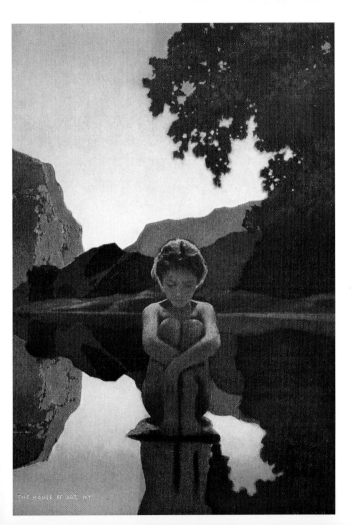

The new interest in Parrish and his contemporaries also caught the interest of the painting and art print world. Young art and print collectors turned their attentions to the late nineteenth century and early twentieth century artists, where a vast field of incredible art lay waiting to be discovered. Parrish was a favorite, of course, as much of his work had survived and so much had been printed.

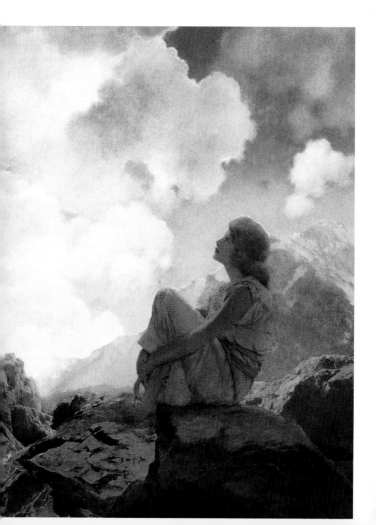

Dreaming
1928

In fact, young and eager collectors
found that there was a love of
Parrish's art that had never died.
Even in the 1970s, many elderly peo-
ple still had original framed prints of
Daybreak, Stars, and *Garden of Allah*
hanging in their homes.

As popular as he is today, Parrish
was just as well loved in his own time
and so was the art print in general.
When Parrish was born in 1870, the

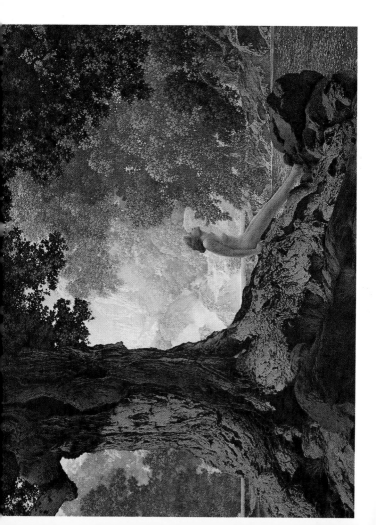

"art print" was also coming into exis-
tence. A by-product of the Industrial
Revolution, the art print gave the
average person a chance of owning
good quality versions of famous paint-
ings — art having been originally only
the province of the rich. Advanced
technology in the printing fields over
the next fifty years had brought litho-
graphic, photographic, and color stan-
dards up to new levels of quality. The

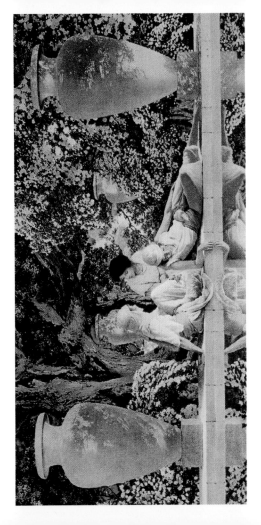

public's demand for more art created an art print market which drew many romantic souls to its ranks. A new art venue was born whereby an artist's work could be viewed by vast numbers of people. Out of the hundreds of artists who contributed to the art print market, only a handful achieved celebrity status or acquired considerable wealth. This required, among other things, for an artist to have a

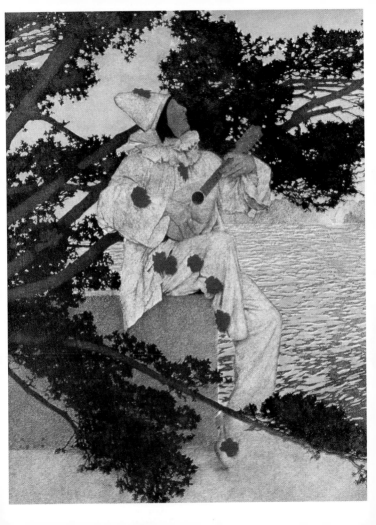

very good sense of what the public demanded and a highly attractive, noticeable style. Fortunately for Parrish, he had both.

Parrish's first art prints appeared in 1904. They were reproductions of covers he had done for the *Ladies' Home Journal* and were sold through the magazine by mail order. These sold well enough that Charles Scribner's Sons, the publisher for

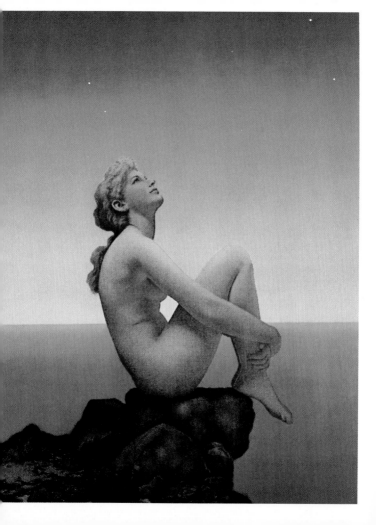

whom Parrish did book illustrations, offered art prints of four illustrations the artist did for Eugene Field's *Poems of Childhood*. The enthusiastic reception for these prints led Scribner's to reproduce more illustrations from that book.

Curiously, very few Parrish "prints" would appear until 1916. It was in that year that Parrish completed a commission that would eventually

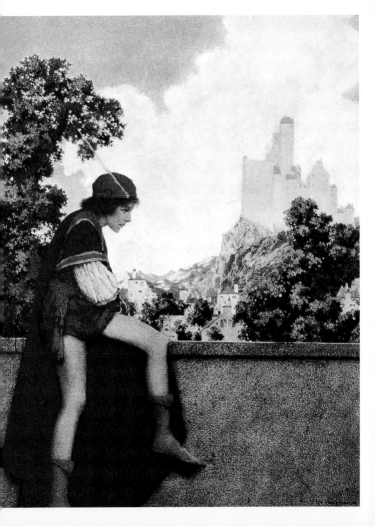

lead him to create his most famous print works. A gentleman named Clarence Crane, who owned Crane's Chocolates, approached Parrish to design a logo for the gift boxes that held his candy. Parrish's small decoration showing a crane (the bird) pleased Crane immensely and he commissioned Parrish to create a painting for the decoration of the 1916 Christmas gift box. Crane

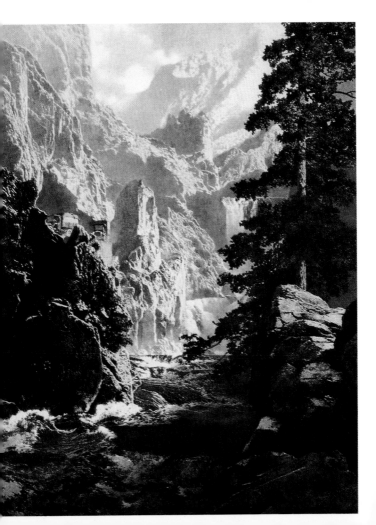

requested the subject to be the
Rubaiyat of Omar Khayyam. Parrish
created the beautiful and well-known
Rubaiyat, redolent in visual splendor
and Parrish's trademarks: the reposed
maiden, shadowing trees, and
panoramic, color drenched scenery.
(Both the artist and client considered
the idea of placing a box of Crane's
chocolates in the scene – fortunately
it was dropped.)

When Crane received the original
painting in mid-1916, he was so
inspired he decided to have prints
made not only for the box, but to also
have full-sized prints of *Rubaiyat*
made and available through a mail
order coupon in each box of choco-
lates. This early example of market-
ing wizardry produced an instant
burst of public enthusiasm. With this
success, Crane requested a box for
1917. Parrish delivered another piece

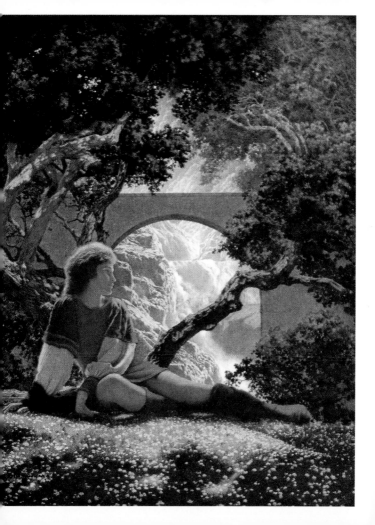

Air Castles
1904

of his brand of exotica with the paint-
ing *Cleopatra*, featuring an flapperish-
looking Cleo on her barge with ser-
vants in attendance. This also met
with much popularity, but Parrish
was tired of doing advertising.
Having to paint what other people
dictated was not how he envisioned
his art career. This highly particular
artist found a chance to achieve his
goal when the fine art publishing
firm, the House of Art (who was at

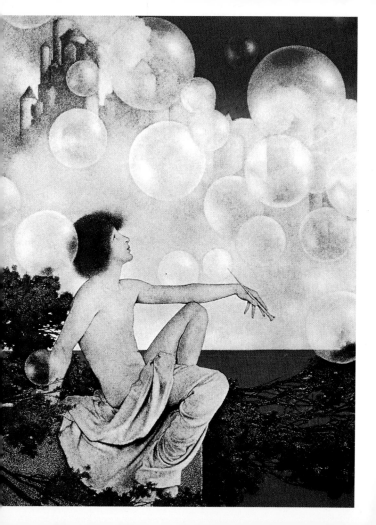

the time marketing Parrish's art
prints for Crane) asked him to create
images specifically for them to repro-
duce and market. Better yet, the pic-
ture subject could be the artist's
choice. Though Crane made a huge
offer for the next gift box design,
Garden of Allah would be the last piece
Parrish would produce for Crane's
Chocolates. Sales of the reproductions
of the art prints skyrocketed and
Parrish moved on with confidence.

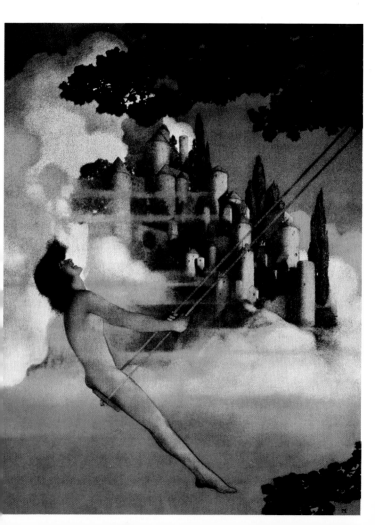

Wynken, Blynken and Nod
1905

The House of Art immediately
began turning some of Parrish's mag-
azine covers and other works into
saleable art prints. It was not until
1923 that Parrish created the first
piece specifically for the House of Art.
Inspired by the success of *Garden of
Allah*, Parrish strove to recreate a
similar but unique vision. For this
Parrish would sweep together all the
images to create this landmark piece:
majestic, piercing mountains, dramatic

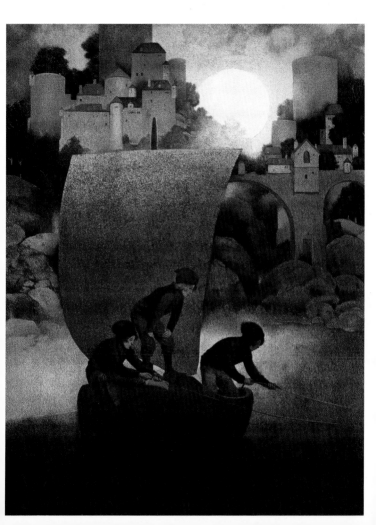

sweeping clouds, twilight blue skies,
and Neo-Romantic young women in
diaphanous gowns (or sometimes
unclothed, like in the print *Stars*),
lazily languishing amid Greco-
Romanesque or Far Eastern architec-
ture. The print, titled *Daybreak*, was
finally offered in the fall of 1923.
Neither the artist nor the publisher
was ready for the incredible populari-
ty of the piece. You might even say
there was a "craze" for *Daybreak* at

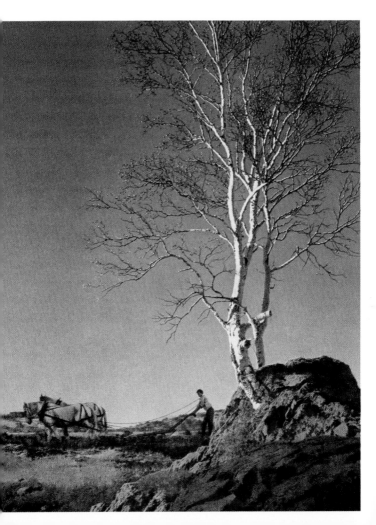

one point. It became *the* giftware item of the day and everyone from grad students to grannies bought one. The popularity of *Daybreak* was so far reaching that it stretched from the consumer into the art field. Throngs of young illustrators and artists offered their variation on *Daybreak's* theme, along with a multitude of exotic gardens, enchanted isles and classical settings. Many were, at best, mediocre attempts.

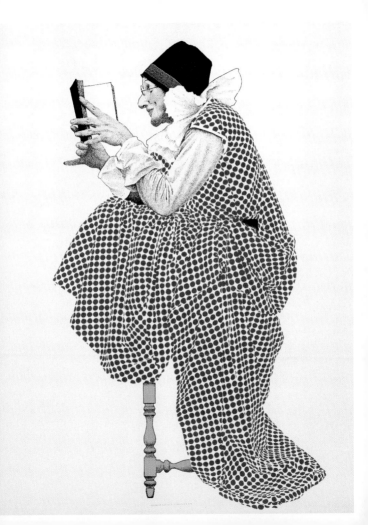

Prince Codadad

Over the next year or so, the House of Art continued to reproduce older Parrish works which had not been seen before on such mass scales. The phenomenal success of *Daybreak* encouraged the House of Art to press Parrish into creating another *Daybreak*-like blockbuster. Parrish submitted two new paintings for reproduction: *Stars* and *Hilltop*. *Stars* featured a nude female figure sitting

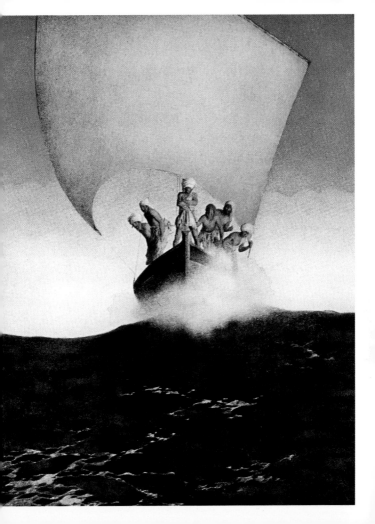

perched on a high crag with just sea
and sky in the background, and
Hilltop shows two maidens sprawled
under a shadowing tree atop a hill.
These two pieces of work became
available to the public in 1926. Their
sales were not as spectacular as
Daybreak, though they still made a
substantial profit for both artist and
publisher. The last collaboration
between Parrish and the House of

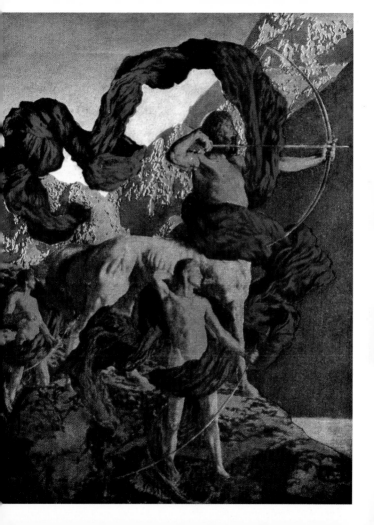

Art came with the release of *Dreaming*
(also called *October*) in 1928. *Dreaming*
was, in fact, basically a landscape
painting (which was the artist's aspiring
field) showing a Parrishesque wooded
river setting featuring a large, ancient
tree in the foreground and a nude figure
seated on one of its gnarled roots. The
figure was added only at the request
of the publishers, who felt that it was
needed for "sales" purposes.

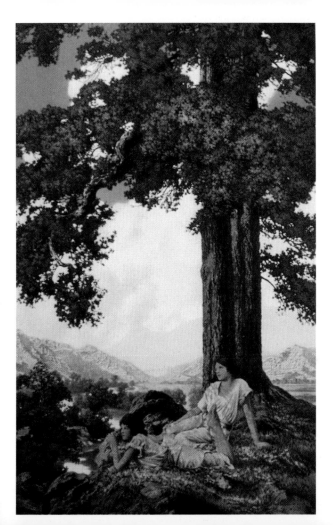

By 1930, Parrish had become dis-
gusted by the demands of the art
print field to dictate the images which
he wanted to paint – not an unusual
feeling for many artists. With sales of
Dreaming dropping off, it became
clear for the artist to make another
move. The *Daybreak* craze was mostly
over – the images of languid, inno-
cent feminine beauty in bucolic land-
scapes so dear ten years ago were
giving way to platinum blonde pin-

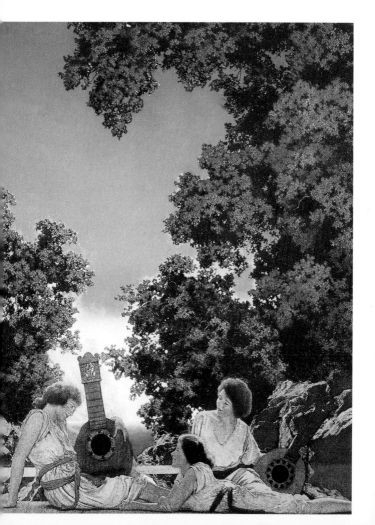

ups, Hollywood starlets, and cultured gardens. The pressure to create another *Daybreak* seemed ludicrous. Though all dealings between Parrish and the House of Art were over, the publishing firm continued to sell art prints of many of Parrish's most appealing works for years to come.

Parrish was able to turn his back on the genre-infested world of art prints when the calendar company

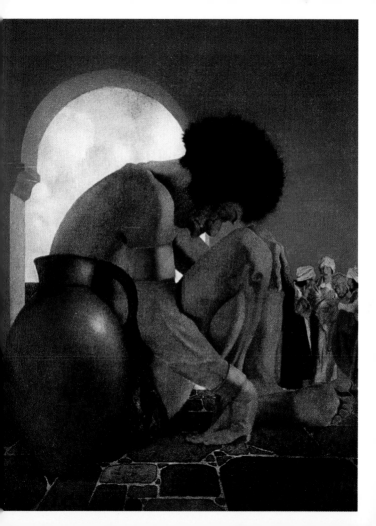

King of the Black Isles
1907

Brown & Bigelow offered to let
Parrish paint landscapes for their cal-
endars. Parrish was at first reluctant,
already contributing art for General
Electric's Edison Mazda line. But the
idea of landscape painting with rela-
tive freedom of subject was too entic-
ing. After his last calendar for
General Electric in 1934, Parrish
accepted the offer from Brown &
Bigelow to provide one landscape a

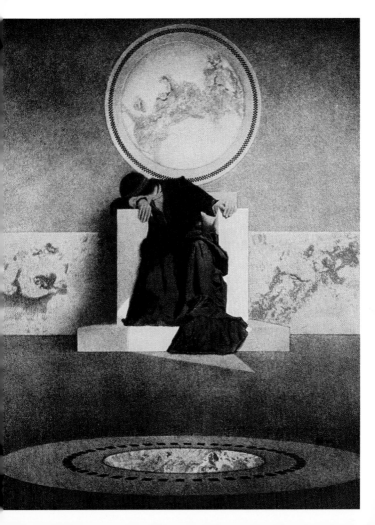

year for use on calendars. This series
ran from 1936 to 1963 and included
winter landscapes for greeting cards
and small calendars. The evocative
landscapes, with titles such as *Twilight,*
The Old Mill Pond, and *Tranquility,*
would employ all of Parrish's paint-
ing and color techniques on more
realistic and serene images than his
fantasy work of the past. He would
never return to commercial art as a

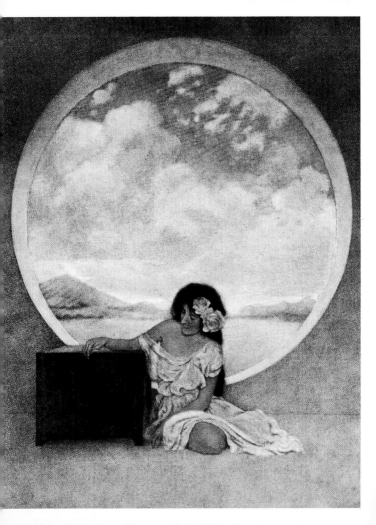

steady diet. Parrish stopped painting in 1962 at the age of 91. He died three years later at his home in Cornish, New Hampshire, where he had lived most of his adult life.

Today the name of Maxfield Parrish has become so entrenched in the American psyche that the phrases "a Parrish sunset" and "a Parrish maiden" conjure up specific images in

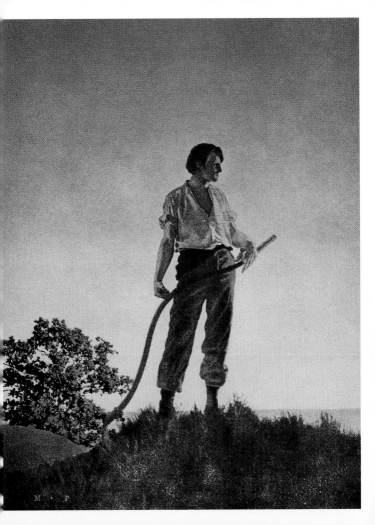

everyone's mind of the work and style of this country's most beloved illus-trator. His use of color was so unique that the beautiful blue he created for his skies has come to be referred to as "Parrish Blue."

Maxfield Parrish's star is not likely to dim in the near future. Reprints of his incredible art can be found in books, posters, postcards, and even trading cards. Interest in

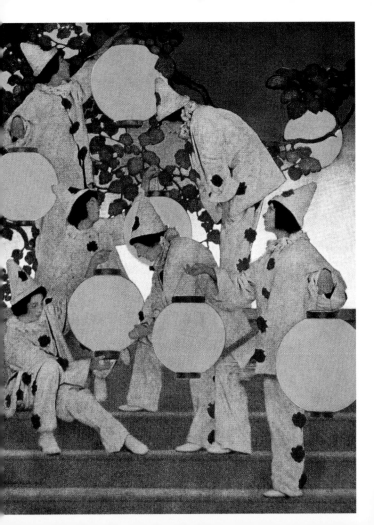

Sugar-Plum Tree
1905

the artist's original prints and calen-
dars has grown into a legitimate field
of collecting. New collectors stand in
awe as they discover why many
before them keep returning to Parrish
– because his work is stunningly
beautiful and can truly be called the
pinnacle of the art print in the earlier
twentieth century.

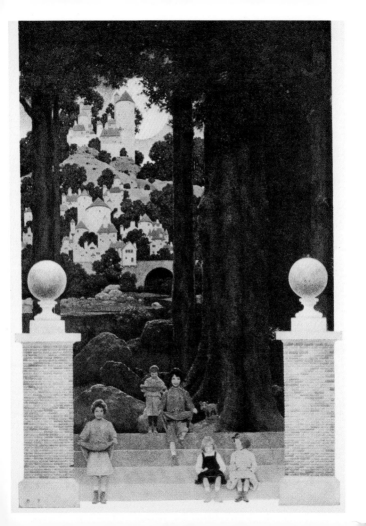

Vignettes